THE ROAD TO CHARACTER

: This is a quick read summary based on the book
"The Road to Character"
by David Brooks

NOTE TO READERS:

This is a Summary & Analysis of The Road to Character, by David Brooks. You are encouraged to buy the full version.

TABLE OF CONTENTS

OVERVIEW

This review of the bestselling book *The Road o Character* by David Brooks includes a detailed summary of each chapter, followed by an analysis. The main theme explored in the book is that our modern culture has lost its way in terms of teaching new generations the path to building character. Using data gathered from polls and psychological research the author makes the case that people are more isolated, more self-absorbed, and less able to engage in moral reasoning than generations past.

The main thrust of the work is a series of what the author calls moral tales about several important historical figures drawn from memoirs, journals and public records. Brooks shows how these people developed strong character through embracing the qualities of humility, self-discipline, and moral realism. He suggests that the road map to building character is in the willingness to engage in the struggle between our virtues and vices towards the goal of living a more moral life.

David Brooks is a conservative columnist for The New York Times, senior editor at The Weekly Standard, and contributing editor at Newsweek and Atlantic Monthly. He is also a regular analyst on NPR's "All Things Considered" and the "Diane

Rehm Show." He has authored several books on American culture.

SUMMARY

INTRODUCTION

In this introduction the author explains the primary topic of the book and some of his reasons for his interest in the subject. He begins by making a distinction between what he calls résumé virtues and eulogy virtues. Most of our lives in spaces such as school and work we are taught and encouraged to develop résumé virtues, such as professional skills, that help us attain career success. Brooks argues that eulogy virtues, those things about us that amount to how we are remembered, are too often overlooked.

Borrowing from an influential perspective from Rabbi Joseph Soloveitchik's 1965 book, *Lonely Man of Faith*, Brooks suggests that these different kinds of virtues might also be understood through the metaphor of the opposing sides of human nature found in Adam I and Adam II. Adam I represents drives for external validation through career success, material accomplishment, and conquest. Adam II is driven by higher moral virtues such as a desire to be a good person, to love well, and to sacrifice for the needs of others. These internal drives are often in conflict in our lives.

According to Brooks they have different logics: Adam I embodies economic rationality and Adam II exemplifies the logic of morality.

Our culture has a tendency to nurture Adam I over Adam II because of the pressures of competition, the noise of constant communication, and the utilitarian focus of consumer society. Brooks argues that if we allow ourselves to develop only the Adam I sides or our nature then we become what he calls a shrewd animal, that is, someone that loses sight of the greater meanings of life. In short, a person that becomes Adam I alone lacks character. This book is thus an attempt to ruminate on what ways that people can develop their Adam II sides. The book will follow this theme through a number of biographical essays, each with their own moral lessons.

CHAPTER 1: THE SHIFT

The author begins this chapter by contrasting two very different moments of victory. First is a response of humility expressed after the Allied victory in WWII on a radio program from 1945. Second is a moment of self-congratulatory celebration after a winning play of a recent football game. The author uses these contrasting moments to suggest a fundamental shift in culture from one where self-effacement is valued and encouraged to one where self-aggrandizement is the norm.

At first the argument seems to be based on nostalgia, but the author then shares some data to support this claim. When Gallup polls asked seniors in high school if they thought they were very important people only 12% said yes in 1950, while 80% said yes in 2005. Median rates on psychological tests for narcissism have gone up 30 percent in twenty years. Desire for fame has also risen drastically, particularly among young people. In popular culture the messages have also changed. In media everywhere from cartoons to sermons, Brooks shows evidence of what he calls "the gospel of self-trust" encouraging people to chase their inner truth and follow their individual passions.

Brooks argues that humility is a quality less promoted in our culture today. For him humility is centrally about being self-aware of one's own limitations of knowledge which goes hand in hand with true wisdom. Awareness of weaknesses within themselves lead the wise and humble to engage in an internal struggle to live a moral life. People that are humble, argues the author, are moral realists who are aware of their flaws and engaged in a journey to triumph over them. Character for such people is something that is built as a result of this process of self-reflection and practicing living by moral standards. Borrowing from Immanuel Kant, the author uses the metaphor of crooked timber to explain this belief system.

In the closing paragraphs of the chapter the author introduces the idea of the U curve. He suggests that people with strong character may come from any walk of life but they tend to share having been down and then rising up relative to crucible moments of great moral struggle in their lives. They tend to come out of such struggles with a strong sense of self-respect and self-reliance. By focusing on the stories of such people the author hopes the reader will take away some important lessons that will benefit them in their journey.

CHAPTER 2: THE SUMMONED SELF

In this chapter the author challenges the reader to consider the value of being summoned to vocation by the circumstances of one's life. He contrasts this way of discovering our life's purpose with a more modern notion that our purpose can be found through deep introspection to find our own passion. He does this mainly through the exploration of the life of Frances Perkins using source material from her diary and public records. Over the course of the chapter he also draws the reader's attentions to certain qualities of Perkins' character.

Before delving into biographical detail about Perkins life, the author describes how being a witness to a garment factory fire in 1911 was a turning point in her sense of commitment to the cause of labor issues. He uses this moment in her life to draw a moral lesson central to the chapter: the external circumstances that we find ourselves in is where we can find our purpose in life. He then turns to Perkins' life and recounts biographical details along with a cataloguing of her various virtues.

Perkins (1880-1965) came from a well to do family and a tradition of progressive commitment to the causes of the disenfranchised. In the days when Perkins was a child, it was more likely that parents would confront them about their weaknesses rather what Brooks characterizes as the excessive

praise of modern parenting styles. This helped Perkins internalize a certain kind of austerity.

She was a student at Mount Holyoke College, class of 1902. It was a time when school teachers and administrators were focused on student morality and accountability to strict and specific codes of conduct. Brooks idealizes this model somewhat and compares it to educational practices today that allow for much more student autonomy and focus more on strictly academic matters. Through a series of interactions with mentors during her time at Holyoke, Perkins learned to appreciate self-discipline, emotional reservation, and humility in regards to her accomplishments. Brooks also argues that Holyoke further ingrained in Perkins a capacity for reflecting and confronting her natural weaknesses.

After some searching, Perkins went to Hull House which was a model of social service that included working side by side with the poor in Chicago. The institution's aim was to have women from the upper class find purpose through service with the poor and to try to replace a sense of community that many thought had been lost as a result of industrialization. Here Perkins was trained to guard against feeling superior to the poor and developed a sense for the importance of data collection and empirical frameworks for understanding urban poverty.

Later, while working with the National Consumers League in New York, Perkins engaged in a variety of projects concerned with child labor issues. Over the course of these experiences Perkins learned to not over invest her identity into these causes and this allowed her to make compromise on the road to achieving political gains. Brooks argues that because she learned to dress more matronly to invoke a sense of connection with male politicians who resonated with women mostly as mothers, Perkin's was demonstrating that her identity was second to her investment in her causes.

Brooks also articulates in some detail aspects of Perkins' family life and professional life as she comes to take public office and finally to serve as Secretary of Labor during the FDR administration. Along the way he details virtues such as humility, reticence, and a strong competence with her work. Despite facing impeachment hearings during her tenure, Perkins served for six more years after being cleared of charges, facing the ordeal with a strategy of non-engagement with the press.

Brooks returns to the idea of a summoned life in the final paragraphs of the chapter. He paints a picture of Perkins as a great figure because of her willingness and ability to absorb herself in her vocational calling over that of selfish interests or vain attachments to external validation.

CHAPTER 3: SELF-CONQUEST

The author examines the life of Dwight Eisenhower in this chapter to explore the virtue of self-conquest. He starts with a brief biographical sketch of his parents, Ida and David Eisenhower. Ida was orphaned at eleven and sent to serve as a cook in a household that took her in. Despite facing economic hardship and great loss at a young age, Brooks describes Ida as both industrious and fearless. At fifteen she ran away and enrolled herself in high school in Staunton, Virginia. She earned good grades through determination and hard work and attended college at Lane University where she met David.

David is described by Brooks as a dour and difficult man who made brash business decisions. After one failing business venture he and Ida moved to Texas where he did manual labor and lived in poverty in the shacks along the train tracks. For David, like for Ida, tragedy and death in childhood shaped him. Both of them were strongly religious and prioritized self-discipline and temperance as strategies for coping with the uncertainties of life.

At this point in his story, Brooks turns to the concept of sin. First he argues that the modern concept of sin is watered down by meaningless use and association with a war on pleasure and over indulgence rather than a more traditional understanding

of the term as the personal embodiment of evil. He suggests that we reclaim the term sin and recognize its value as a word reminding us that life is a moral endeavor. The concept of sin helps remind people that we are all connected through the commonality of sin, that is, we all fall morally short. The concept of sin is critical for Brooks because it is through struggling with sin in our lives that we build character. Additionally, having a vocabulary of different sins and their remedies helps people engage in that process. He argues that this moral ecology that used to be handed down through generations has largely been lost in modern America.

Returning to the Eisenhowers, Brooks relates that they saw self-restraint and controlling internal impulses as a highly esteemed virtue to be learned and practiced at every occasion. Through the control of behavior, one could become a good person. Manual labor, in this vein, was also valued as a means to build character. These were the kinds of values that were a part of the childhood environment for Dwight Eisenhower.

Despite being raised by very religious parents, Dwight Eisenhower was not himself terribly religious, although he valued religion as beneficial to society. He did however, hold on to the ideas of the internal struggle against the worst of our natures. As a child and a young man in military service Eisenhower was prone to some rebelliousness and even rage. During his military career however, Eisenhower started to

struggle with his overly expressive nature, eventually learning to master restraint.

In 1933 Eisenhower served under General Douglas MacArthur for several years. Despite serving with a humble attitude, Eisenhower's private journals reflect a disdain for MacArthur's grandiose leadership style. He came to see war as not a romantic vision for the opportunity of heroics, but rather as a duty to endure. Brooks suggests that is was this restraint that ultimately served Eisenhower as a stand out commander during WWII, in particular in terms of holding strained national alliances together. The cost of so much restraint, however, also showed in his administration and personal life.

At this point Brooks departs the historical narrative with some philosophical musings on the modern notion of the authentic self. He suggests that it was one of Eisenhower's great strengths to be able to show such remarkable restraint. This lies in contradiction to the modern notion that self-expression should be valued above such restraint. For Brooks what Eisenhower did was to carefully cultivate his public self to better serve in his various capacities rather than allow his raw inner self be the face that he showed the world.

The final virtue that Brooks explores through the life of Eisenhower is moderation. Brooks argues against a thin understanding of moderation as simply a midpoint between two opposing positions. He suggests that moderation is

actually about accepting the inevitability of conflict and being able to balance the different priorities in the moment, driven by the complexities of context. It is a kind of acceptance of the insolvability of some problems, and having the skill to forge a reasonable path even in the face of a lack of resolution and the presence of ongoing opposing trade-offs.

CHAPTER 4: STRUGGLE

The author recounts the life of Dorothy Day, prominent Catholic social activist, in this chapter. The theme of the chapter is to see in Day a kind of ongoing inner struggle that Brooks argues was central to her character development and was the engine behind her lifelong sacrifices for the poor.

His story begins when Day was eight years old. An earthquake struck in Oakland California in 1906 leaving the town temporarily disabled by the destruction. In the aftermath Day saw how the people came together and loved and cared for each other as a result of their shared crisis. Early on in her life, Brooks suggests, there was indication that Day was searching for a "pure" life. Her teenage writings show a desire to find a transcendent purpose for which to sacrifice her material desires. For example, at fifteen her writing showed a deep struggle between her awakening sexual desires and a sense that she saw her purpose as spiritual person as one of denying those desires and struggling against sin. Her intense self-inspection and willingness to be critical of her failings was central to her process of finding character.

As a teen Day diverged from religious thinking and instead became interested in political activism and had a particular affinity for socialist thinking, writing and organizing. At

eighteen she moved to New York and her memoirs describe a terrible loneliness that she felt there. She came to find community among the bohemian artists and activists of that era. During this period she engaged in the heavy drinking and later some of the sexual promiscuity that were part of the cultural landscape of this countercultural movement. Meanwhile, her internal struggle went on as a sense of dissatisfaction haunted her.

During the flu epidemic of 1918 Day volunteered as a nurse at a hospital where the staff was organized with military style leadership. It is here, that she came to understand the importance of self-discipline as a means of organizing people. Over the next few years she continued to engage in activism through political protest and writing, however, Brook characterizes this period as a willy-nilly engagement with various struggles without a transcendent framework that would create the sense of a pure cause. Along the way her ongoing scrutiny of her work continued to drive her to feel dissatisfied.

Brooks also describes that during this period she met and fell in love with bohemian Forster Batterham, with whom she had a daughter, Tamal. It is in fact the birth of her daughter that brings Day back to a connection with God. Her interest in the Catholic Church was connected to her desire to share the journey of the poor many of whom were members of that faith.

As she became more involved in the Church her relationship with Batterham became more strained and eventually ended. Brooks describes this time as not one of sudden tranquility at having found a pure purpose, but rather as another episode of intense doubt and internal struggle for Day.

In 1933 Day started *The Catholic Worker*, a newspaper dedicated to labor issues and organizing a general movement in the Catholic Church around the issues facing those living in poverty. Brooks emphasizes Day's disdain with service to the poor that was self-congratulatory or prideful. Day lived alongside those she worked to help choosing a road of suffering on spiritual principle and as a form of solidarity with those she served. Brooks contrasts this with those he calls the "do-gooders" of today, highlighting that for many such service ultimately is about serving the self-centered interest of pride and the absolution of guilt. He argues that Day also saw this divide articulated in her disdain for the celebration of the self that manifested in the counterculture movement of the hippies and their brand of agitating for social justice.

Chapter 5: Self-Mastery

In this chapter the author explores the virtue of self-mastery through the life of George Catlett Marshall, whose lifetime accomplishments include authoring the Marshal Plan, receiving the Nobel Peace Prize, and holding the offices of Chief of Staff, Secretary of State, and Secretary of Defense.

In his youth Marshall contended with periodic poverty, mediocre academic performance, and deep personal humiliations particularly relative to school. Brooks describes him as both rebellious and extraordinarily self-conscious. A turning point for Marshall was his experience at the Virginia Military Institute. Marshall became invested in the moral culture of that institution which included commitment to honor, service, and self-discipline. Honor was trained into cadets by teaching them to revere the great leaders of history. In so doing cadets were given models of conduct to strive for. Brooks contrasts this with more modern styles of education which he positions as more directed at helping students find greatness that already exists within themselves. Greatness, he argues, is cultivated from the outside in.

Brooks illustrates that Marshall, who was not at the top of his class academically, was able to shine by devoting himself to strong service to the institution and through exemplifying

qualities of value to that culture including self-discipline, organization, and leadership. Brooks contrasts the emotional restraint showed by Marshall with the more self-expressive cultural norms of today suggesting that something important has been lost with this cultural shift. His argument here relies on the idea that great individuals are made through training and mastery over raw emotions of the self.

These virtues became central to Marshall's leadership style as he continued his career in the U.S. Army. His early career was not marked by fast advancement or by a great deal of pomp concerning his accomplishments. Brooks describes more of a slow march during which time Marshall's dedication to the Army as an institution led him to gain skills and respect as a logistical coordinator and assistant to influential generals. He was passed over time and again for promotions. He was so good at the administrative work of logistics and operations that he was deemed essential to that kind of work and higher ups did not perceive him as best utilized as a commander of troops. In the face of such disappointments however, Brooks describes Marshall as an Organization Man who placed the decisions of the institution before his own ego. This virtue of self-denial is lauded by the author as central to Marshall's outstanding character.

Another way in which Marshall's stoicism is highlighted by Brooks is through the lens of his personal life. Brooks

maintains that Marshall had a rich emotional life with his wife Lilly, but he maintained a very rigid boundary between his private and professional life. He contrasts this with more modern styles of the personal and professional which tend to celebrate a kind of blurring of that boundary.

It is when the Fascist threat became more clear in the 1930's that Marshall's merit began to be more highly recognized and he started to receive recognition through a series of promotions. Brooks describes a few salient moments where Marshall made himself visible to people in power. One such episode was in 1938 where he made a case to FDR that indeed ground troops would also be important in the looming war in contrast to others that were making the case that only air and sea power would be strategically central. As a result, when the vacancy of Chief of Staff opened in 1939, Marshall was a top candidate and despite not campaigning he was selected for the post by FDR.

Marshall remained committed to serving the institution over his own ego, argues Brooks. An important example offered is that when considered for the command post of an important invasion, Operation Overlord, Marshal refused to influence the decisions of higher ups by making personal appeals or leveraging his institutional allies. Instead, when finally brought before the president and asked if he wanted the position, Marshall simply stated that he would gladly serve in

whatever capacity the president desired. He was denied the command which was a great personal disappointment. Brooks makes the case that what made Marshall a man of great character was his consistent sacrifice of his personal ambitions and desires to the needs of the institutions in which he served.

CHAPTER 6: DIGNITY

In this chapter Brooks investigates the lives of two important civil rights activists A. Philip Randolph and Bayard Rustin. Both of these men were contemporaries of Martin Luther King Jr. and were both influential men in the nonviolent struggle for civil rights. A moral focus of the chapter is the virtue of dignity.

The author starts with a biographical sketch of Randolph. Randolph's father was a minister of the African Methodist Episcopal Church which had a framework of Christianity that integrated racial and social awareness as part of its evangelical mission. Although extremely poor, Randolph's parents insisted on his education, the cultivation of genteel social graces, and teaching him exceptional oration skills. These qualities that Randolph would come to embody are what Brooks equates with having dignity. In addition Brooks revisits self-mastery and suggests that this quality too was a part of Randolph's character development.

Brooks paints Randolph as a person who maintained a high level of morality in his personal affairs. For example, despite attracting much attention from women, Randolph resisted the temptation to be promiscuous. He rejected opportunities for personal wealth that he deemed as compromising to his social

justice mission. He was highly regarded as incorruptible and his respect over time largely hinged on these qualities.

In 1911 Randolph moved to Harlem and participated in a variety of socialist organizing activities, and then ironically married into a genteel Harlem family. He remained committed to labor organizing and spent over a decade involved in organizing a porter's union for black workers for the Pullman Company. Instead of focusing on Marxist ideology which was off putting to workers who had a sense of loyalty to the company, he framed the struggle as one of dignity. A sea change finally happened when the labor laws under the Roosevelt administration finally forced the company and union leadership to come to terms reducing the work month from 400 to 240 hours along with substantial salary increases. Randolph was also an influential champion of the tactics of nonviolent resistance. Brooks links these tactics to the virtues of self-discipline that Randolph embodied.

At this point in the chapter the author changes focus to the life of Bayard Rustin. Like Randolph, Rustin had parents that encouraged dignity though self-control, mastering European styles of oration, and the importance of education. One contrast that Brooks draws, however, is that Rustin, who was gay, lacked self-control when it came to his sexual life. His sexual promiscuity would be cause for his dismissal as a leader in some cases, and worse a way to discredit the movement

more generally speaking in some cases. None the less, his organizational prowess evident in his participation in orchestrating a wide variety of political protests and sit in's, and his commitment to the principles of nonviolent confrontation, earned him the respect of other leaders such as Randolph and King. However, because his personal life was a site of potential dismissal, a good deal of his work remained behind the scenes as leaders in the movement were concerned his questionable moral character would mar the movement as a whole.

In the concluding remarks of the chapter, Brooks points to how the combination of commitment to higher ideas and the virtue of extreme self-skepticism, is a path for those seeking social justice to engage not only the powers of evil in the world at large, but also the internal struggle against sin.

CHAPTER 7: LOVE

In this chapter Brooks looks at the life of Mary Anne Evans, the famous author known to the world as George Eliot. In this moral tale he describes the role of love in transforming Eliot from a self-absorbed and desperately clingy young woman into a deeply sensitive and astute novelist whose work has had a profound impact on literature.

Eliot was born in Warwickshire England in 1819 as the daughter of a modestly successful self-made man. Her mother was ill for most of her childhood was not very affectionate. She was sent to boarding school at the age of five and recalled to manage her household at the age of sixteen when her mother was dying of cancer. This lack of affection from her parents, argues Brooks, created in her a deep fear of abandonment and an immature need for external validation. In her late teens she threw herself into a deep devotion to religious ideas and practices focusing on renunciation of sin and abstinence from celebration unless it was in worship.

However, Brooks describes that because of her intelligence and lust for life she could not be contained by those principles for long. She started to read more of the Deist ideas of the day that departed from Christianity in important days. She found intellectual equals among others who believed that the moral

teachings of Christianity were important, but that miracles and other fantastic parts of biblical teachings were a mix of fiction and history. The departure with the church also caused a rupture with her remaining family who were mortified by the deep and severe social consequences and scandal.

She also started to become interested in the attentions of men. As a result of the lack of affection as a child, Eliot's romantic life was characterized by a strong sense of emotional dependence on numerous romantic encounters with men. The emotional clinginess that followed Eliot during this period was accompanied by numerous rejections by men and left her feeling terribly lonely. Brooks recounts several such disasters. This changed in 1852 when she met the love of her life, George Lewes, who requited her love.

Despite the fact that Lewes was married, the two ran off together and his love for her and admiration for her talent as a writer enabled her success as an author. Key for Brooks in this story is that their mutual love for each other was transcendent. That through their love, Eliot was rescued from the self-absorption that characterized her youth and enabled her to fully mature into a writer with a clear genius for understanding not only herself, but other people.

CHAPTER 8: ORDERED LOVE

The central theme of this chapter is a further exploration of the struggle between moral weakness and strength through the biography and ideas of Aristotle. Augustine was born in 354 into a middle class family in the town of Thagaste. His father was a minor public official and his mother was notoriously possessive and controlling both in the household and in Augustine's life. Brooks argues that he was caught between the competing worlds of Hellenism and Judeo-Christianity and this inner struggle was central to his early life. A Hellenistic framework encouraged one to see the beauty in the world as it is and to have a spiritual flexibility determined by what they observe there. The Judeo-Christian model, in contrast, encourages one to see that there is an immortal higher order and to strive to attain harmony with that, a kind of transcendent spiritual reality. This inner conflict, suggests Brooks, was part of a sense of unease for Augustine. He was successful in terms of achieving external success, but his inner spiritual life was in turmoil. In addition, although he was perceived as a hopeful up and coming prodigy, he felt increasingly isolated.

After a fifteen year common law marriage with a woman from a lower social class with whom Augustine had a child, his mother intervened and forced an arranged marriage to a ten

year old girl who was deemed to be from a more appropriate social class. Brooks argues that this sacrifice in the service of social status was typical of Augustine's life until his late twenties. At some point Augustine has a crisis realizing that the material success is not satisfying his soul and his solution was to engage in vigorous self-reflection. One conclusion he came to see was that humans come to desire the wrong things through sin, and that people should regard with a measure of distrust the desires that seem to spring from within. Another conclusion that Augustine draws is that there is a path to the infinite and divine also living within. Both the human capacity for sin and the desire to transcend and strive towards the divine are both universal.

Augustine also came to see each virtue as being connected to a vice. The examples given by Brooks are self-confidence and pride, honest and brutality, and courage and recklessness. He came to also see that a fatal flaw in his life was his belief in the idea that he could fully control his own life. In fact, he linked this very notion with the sin of pride. Augustine also believed that the desires of life were distractions from satisfaction since no matter how much one attained of fame or recognition, they always seem to want more. However, he struggled with renouncing such things as well. His radical renunciation of worldly pleasures came suddenly, however, in a scene that Brooks describes out of Augustine's work *The Confessions*.

Brooks then changes tone from an historical narrative to a more philosophical investigation of Augustinian Christianity. He argues that Augustine did not perceive human nature to be all bad, but rather that without direction towards God people will be restless and discontent. Further, the idea of God's grace in the Christian ethos is that God loves all those that he creates, regardless of our worldly accomplishments. That is, God does not love us for good deeds, but accepting God's grace can uplift us from despair and give us a tremendous appreciation and a desire to reciprocate that gift. Through that shift in perspective Augustine argued that our entire selves are realigned and can find peace.

CHAPTER 9: SELF-EXAMINATION

Samuel Johnson was born in 1709 in England to parents in an unhappy marriage. He was a sickly child and endured many hardships of illness into his adult life. His education was stern and steeped in both the classics and corporal punishment. He also educated himself by being an avid reader of all things. At nineteen, funded by a small windfall in the family, he attended Oxford where he experienced isolation because of the gap in social class he had with most of the other students, and he reacted with rebellion and resistance to the rules of the institution and cultural norms. However, at Oxford he also found Christianity and in it a God that was judgmental and strict.

He was also afflicted by what historians now believe to be Obsessive Compulsive Disorder as he had severe tics of various kinds and repetitive rituals such as entering rooms multiple times. He married Elizabeth Porter, a woman twenty years his senior. He started a private school with her money that failed. He moved to London and was a freelance writer. By necessity he wrote on everything and everything and had to chase work. Brooks suggests this kind of life caused him to be somewhat fragmented and ungrounded, made worse by his off putting demeanor. He also suffered from great anxieties, particularly at night.

One of Johnson's defining attributes for Brook is the degree of self-criticism he engaged. Of particular concern to him was his off and on style of work habit that never came under control. Despite that he was a prolific ghost writer for the Grub Street press for nearly two decades. Brooks suggests that through writing Johnson came to terms with much of his inner turmoil and developed a cohesive narrative of himself and life in the process. One of the focuses of Johnston's world view was a kind of dualist philosophy, similar to that of Aristotle, where vices and virtues lived in constant tension. His writing used such tensions, contradictions and paradox to reveal complexity.

Johnson was a social being who found himself through the reflection of other people. He was known to be social across all social classes. He was critical of determinism and had a strong commitment to the specifics of the individual. He was also a humanist and a moralist, and like his contemporaries, saw literature as a site for the improvement of humanity. Brooks argues that because of his own severe failings for which there was no cure, Johnson came to have a profound sympathy for the ongoing struggle of people against their frailties.

Brooks notes that many of Johnson's essay reveal a kind of reflection on himself. He writes about themes that are themselves deeply haunting to him. His essays are an attempt to solve the internal struggles by logically dissecting them and

analyzing them in reference to a moral realism that he was committed to.

The author then contrasts the work of Johnson another famous essayist, Michel de Montaigne. Although both writers had different styles, they were both moral realists intent on understanding themselves through their writing and were both committed to high moral integrity in their work. Johnson's style was more direct and confrontational while Montaigne's revealed more bemusement with his shortcomings. Montaigne also had a much different background than Johnson. He was raised in economic privilege and was well educated in elite institutions. Most of his writing was done from the insulation of his private estate after he retired from public life at the age of thirty eight. Despite that, he shared with Johnson a sense of unrest and a need to engage in reflection and moral investigation.

Rather than understanding himself through other people like Johnson, Montaigne worked in the other direction, extending from an investigation of himself qualities that are shared by all people. Montaigne also lacks the kind of hard ambition that Johnson is driven by. He is more apt to lower his expectations for perfection as a path to inner peace than Johnson who was constantly pushing himself to reach an ever rising bar.

CHAPTER 10: THE BIG ME

Brooks begins by comparing and contrasting two athletes who he locates historically on either side of a cultural shift away from self-effacement and towards self-aggrandizement. Johnny Unitas and Joe Namath both grew up in western Pennsylvania steel towns and were only a decade apart. However, Unitas symbolized a form of athleticism that was about the individual athlete subsuming his individual accomplishments to the team. Namath on the other hand symbolized a movement towards athlete branding, individual sponsorship and flamboyant displays of self-appointed awesomeness on and off the field.

Brooks argues that the conventional view holds that the Greatest Generation of Americans, those that saw the first and second world wars, were replaced by the baby boomers who were selfish and narcissistic as a result of the increased material culture. He then suggests this story does not fit the actual facts of history and instead gives another account of this cultural shift. He locates the start of his account at biblical times citing a long tradition of thinkers that focused on the limitations of humans and the constraints on reason to fully understand the experience. It is not until the 18th century, argues Brooks, that moral realism is confronted by a rival paradigm: moral romanticism. This view emphasized internal

goodness where the self could be trusted and the social conventions of society became a site of distrust. For a while they lived in a kind of creative tension, what Brooks describes as a balance, that was lost in the 1940's and 50's. He argues that it was the great consumerism following the Second World War when after years of enduring suffering and loss people simply wanted to escape the horrors of the previous decade and a half. He briefly reviews several bestselling books published at the time that embodied the moral romanticist philosophy. He calls this transition the birth of the self-esteem movement and argues that we are still grappling with it today.

Brooks also acknowledges some positive effects of this shift, more specifically the empowerment of previously disenfranchised groups of women and minorities. He traces several feminist works of the 1960's showing how oppressive attitudes had caused women to internalize doubt and negative beliefs about their own potential, and that the new movement towards self-love was a part of how they liberated themselves.

Overall however, Brooks is critical of the shift. He calls it the shift from Little Me to Big Me. Ruminating on another feature of this shift he talks about a shift towards what Charles Taylor called "the culture of authenticity" whereby people have come to largely believe in the idea that the inner compass is the best moral guide. Instead of engaging in moral struggle people struggle to be true and authentic versions of themselves.

Although not wanting to associate with technophobic thinkers, Brooks locates three ways in which technology has exacerbated the Big Me or Adam I sides of our human nature. First, constant and instant communication creates a kind of noise that interferes with our ability to make space for quite reverie. Second, social media creates an environment that facilitates tailoring to individual desires for content and user defined aesthetic experiences of the world making us more susceptible to feeling like the center of the universe. Finally, social media in particular encourages reporting on every detail of our inner lives and encourages us to be self-promoters.

Brooks argues that meritocracy has become more purified, and as a result extremely competitive. Placed in positions where we are encouraged to highlight individual accomplishments and come to see them as our cumulative legacy. This focus on Adam I subsumes our Adam II natures. It encourages people to seek praise to a fault, and to measure themselves by external rewards. He offers modern parenting as one site where constant praising and skill honing is a part of the modern family landscape. For the author this means that even relationships between parents and their children have become a terrain of conditional, approval based relationships rather than the unconditional love or more Adam II based love.

The primary problem with this shift according to Brooks is the loss of a kind of moral lexicon. Citing numerous studies and

polls he argues that people are more isolated, less likely to have empathy for others, and in general less oriented to things like community. The ultimate consequence is a lack of ability to articulate and engage in moral reasoning at all. Further, since each of us is One True Self, moral relativism is an obvious consequence of this kind of thinking.

Finally, Brooks turns towards solutions. He articulates a short list he calls the Humility Code that he offers as a prescription for a revitalizing of the moral ecology of times lost. Here is a brief summary of the list:

1. A meaningful life includes the struggle to become more morally fit.
2. We need to recognize that it is human nature to be flawed.
3. We are also strong and endowed with gifts and an essential part of becoming more moral is engaging in the struggle of our strengths triumphing over our weaknesses.
4. Humility is our greatest virtue.
5. Our most central vice is pride.
6. Once basic needs for living are met, the most important part of life is the struggle of virtue over sin.
7. Character is a byproduct of the struggle of virtue over sin.

8. Distractions from the core goal, to be a moral person, are short term and temporary. People with character can overcome them with steadfast progression towards a moral life.

9. Self-mastery requires a connection to something outside the self such as God, family, friends and cultural traditions.

10. Grace, which is the fact that we are already accepted by family, or friends, or God, is what saves us in times of our greatest struggle with weakness.

11. Only by quieting the self and the ego can we get clarity.

12. Wisdom has its roots in recognizing the limits of personal knowledge.

13. There is no possibility for a good life without a vocation, a calling to dedication to the work at hand that comes from without, not within.

14. Good leaders believe in incremental change within institutions rather than radical ones.

15. Maturity comes with improving yourself relative to moral improvement, not comparison with external factors.

ANALYSIS

In this work David Brooks offers a colorful reading of several historical figures that will engage many readers. He has chosen a relatively diverse set of remarkable people to craft his moral tales about virtues and character. The book offers an opportunity for readers to reflect on the balance between their external accomplishments and their internal moral lives. The book will inspire some to reprioritize their energies. In particular, it offers a window into how virtues and vices, and the struggle between them, can be a lens through which we might become more self-aware about taking character development in our own lives more seriously.

A strength of the book is the quality of storytelling. Brooks brings these historical figures into an intimate focus. He humanizes their inner struggles in such a way that many readers will find strength and inspiration to engage in the hard work of honest moral inventory that the author is suggesting. Despite probing into the deeply personal failings of his subjects, Brooks manages to never lose sight of the benefits of character that they gained through honestly admitting to and confronting the weakest parts of themselves.

One of the foundational assumptions that Brooks makes in his book is that there are rigid and universal moral codes that

transcend human culture that can be relied on as clear signposts to drive both individual spiritual lives and society more generally. He calls this position moral realism and lauds it as the foundation of strong character, and indeed, good societies. However, he is suggestive that Americans have simply lost this moral realism, rather than engaging, indeed showing any awareness of, the reasons why many modern people have abandoned this construct based on sound rational and ethical rejection of the concept itself.

There are strong critiques of moral universalism of the kind that Brooks argues is central to good society. First and foremost are critiques from disciplines such as cultural history and anthropology that have shown that moral codes developed in Victorian European culture are in fact intimately tied to that cultural and historical period rather than universal human truths. In addition to that, such moral realism was an integral part of justifying colonialism and imperialism under the guise of "civilizing" non-European peoples that had their own distinct moral and cultural codes. Second, social justice movements such as feminism, socialism and civil rights have clearly demonstrated that the moral discourse of the elite has been used as a means to force assimilation into gendered, class and racial regimes that maintain inequality. This is not to say that those perspectives are above critique, but to not even engage them as reasons why many modern people have departed from moral universalism is bordering on

irresponsible. Ironically epistemic modesty, which Brooks argues is essential to wisdom, lives in contradiction to his assumptions about moral realism throughout the book.

The book also suffers from its share of contradictions. In an attempt to reduce the complexities of individual lives to simple moral tales, Brooks runs into trouble. For example, his critique of modern culture's tendency to teach self-reflection as a source of wisdom lives in contrast to several places in the book where he lauds such behavior in his subjects and points to how such behavior led them to spiritual epiphanies. On one hand he argues that being prideful about moral superiority is a vice, and on the other we are asked to conceive of personal moral growth as the triumph of our own virtues over sins, implying a clear moral hierarchy.

The research that the author did in preparing this book shows clear breadth and depth, particularly in terms of the historical content of the book. However, many readers will find that the credibility of the author is compromised by a relentless refashioning of these people's lives into his own conceptions of moral realism and his use of rather spurious data to support his thesis that Americans lack character. His research would have been better showcased if he had chosen a more descriptive, and less prescriptive tone. Had he allowed the reader more agency in exploring the moral dilemmas faced by these people without coercing the conclusion that modern

American culture is hopelessly immoral, the book would have reached a larger audience and had a wider impact.

Despite the critiques mentioned above, it is not necessary to accept either the premise of moral realism or the argument that modern day Americans lack character to take something valuable from this book. Brooks' arguments that modern culture encourages us to see ourselves through a résumé lens rather than a eulogy lens does have merit. The historical narrative that he offers gives us an opportunity to ponder the ways in which we might each go about rectifying that in our own lives. One does not have to accept his particular moral ecology to appreciate the value of an honest moral assessment of ourselves, even if our metrics might be different from that of the author.

Made in the USA
Lexington, KY
11 August 2016